Launching Your NFT Record Label: A Step-by-Step Guide

Music Business

Thomas Ferriere

Published by Thomas Ferriere, 2023.

Also by Thomas Ferriere

Watch for more at https://www.thomasferriere.com/.

Dedication

To F Communications,

The home of innovative and inspiring electronic artists that provided a launchpad for my own musical journey. With deep gratitude, I dedicate this book to the original label of Laurent Garnier.

Founded by Eric Morand and Laurent Garnier in 1994 as a successor to Fnac Music Dance Division, F Communications was a beacon of creative expression that shone brightly until its doors closed in 2008. May the spirit of F Communications live on in the NFT record label revolution.

Launching Your NFT Record Label:

A Step-by-Step Guide

By Thomas Ferriere

clarifying purposes only and are the owned by the owners themselves, not affiliated with this document.

Table of Contents

8.1. NFT Marketplaces Here are some popular NFT marketplaces where you can launch and sell your music NFTs:

8.2. NFT Creation and Minting Tools These tools can help you create, mint, and manage your music NFTs:

8.3. Decentralized Storage Solutions These decentralized storage solutions can help store your NFT content securely:

8.4. Smart Contract Development Tools and resources for developing and deploying smart contracts on various blockchains:

8.5. Legal and Licensing Resources Resources for understanding legal and licensing aspects of NFTs and digital assets:

8.6. Community and Learning Resources Here are some resources to help you learn more about NFTs, blockchain, and the music industry:

Introduction

The music industry is no stranger to innovation and creative disruption. In recent years, non-fungible tokens (NFTs) have burst onto the scene, profoundly altering the landscape of music distribution and monetization. As artists and labels increasingly embrace this pioneering technology, there's never been a better time to explore the idea of launching your very own NFT music label.

This eBook is your ultimate guide for those with aspirations to establish NFT music labels, covering essential topics like deciphering NFTs and the music landscape, crafting a strategy, building a team, navigating legal and financial aspects, creating and minting NFTs, devising marketing and promotional strategies, and nurturing artists and fostering growth. Whether you're a music industry veteran or a newcomer, this guide aims to provide you with the knowledge and insights needed to jumpstart your NFT music label adventure.

As you dive into the chapters ahead, you'll gain a deep understanding of the benefits of incorporating NFTs into the music realm, as well as practical advice on overcoming the unique challenges and opportunities that NFTs present. We'll also explore some standout examples of NFT music releases, providing inspiration and valuable insights into what makes an NFT offering truly captivating.

Upon completing this eBook, you'll have a clear roadmap for launching your own NFT music label, along with an arsenal of resources and tools to help you succeed in this exciting and rapidly evolving space. The future of music is here, and with the right guidance, passion, and determination, you can be at the forefront of this digital revolution. So, let's embark on this extraordinary journey together and unlock the transformative power of NFTs in the world of music.

Chapter 1: Understanding NFTs and the Music Landscape

Welcome to the fascinating intersection of non-fungible tokens (NFTs) and the music industry! As someone who's passionate about both technology and music, I'm thrilled to share my insights and explore how NFTs are transforming the way artists and labels create, distribute, and monetize their work. This first chapter will take you on a journey through the foundations of blockchain technology and NFTs, the role they play in the music landscape, and the exciting opportunities they present for those of us in this rapidly evolving space.

Throughout this chapter, I'll share my personal perspective on the innovative ways artists and labels are leveraging NFTs to create new revenue streams, foster fan engagement, and push the boundaries of creativity. We'll also take a closer look at some of the most successful NFT music releases and collaborations, and discuss the advantages that NFTs offer for both creators and consumers of music.

As someone who's been closely following the rise of NFTs in the music industry, I believe that understanding these concepts will be crucial for anyone looking to launch an NFT music label or simply stay ahead of the curve in this fast-paced, ever-changing landscape. By the end of this chapter, you'll have a solid understanding of the potential that NFTs hold for the music industry, as well as the unique challenges and opportunities that come with embracing this cutting-edge technology.

So, without further ado, let's embark on this exciting journey together and delve into the world of NFTs and music, discovering how they're revolutionizing the way we create, share, and enjoy the art that moves us.

1.1. Technical Foundations of Blockchain and

NFTs

Non-fungible tokens (NFTs) are cryptographic digital assets that represent ownership of unique items or content. They are built on blockchain technology, which provides a secure and transparent infrastructure for verifying authenticity and provenance. Unlike fungible tokens such as cryptocurrencies (e.g., Bitcoin or Ethereum), NFTs are distinct, non-interchangeable, and exclusive.

Blockchain, the underlying technology of NFTs, is a decentralized and distributed ledger system. It consists of a network of nodes, each maintaining a copy of the ledger, which records transactions in a transparent, tamper-proof, and secure manner. The consensus mechanism employed by a blockchain network ensures that no single party controls the data, and that any modifications to the ledger must be agreed upon by a majority of nodes.

NFTs are typically created and managed through smart contracts, which are self-executing contracts with the terms of the agreement directly written into code. These contracts run on blockchain networks (e.g., Ethereum) and enable the minting, transfer, and management of NFTs. By incorporating programmable logic, smart contracts allow for additional functionalities such as built-in royalty mechanisms and customizable access controls.

1.2. NFTs Transforming the Music Landscape

As someone who's been closely following the developments in the music industry, I can't help but feel excited about the integration of NFTs into this space. You see, this breakthrough technology is not only offering artists and labels a fresh, innovative way to distribute and monetize their work but also giving fans like you and me an entirely new method to engage with and support our favorite musicians.

The integration of NFTs into the music industry offers artists and labels a new way to distribute and monetize their work, as well as providing fans a novel method to engage with and support their favorite musicians. The digital nature of NFTs allows for seamless integration with existing digital platforms, and their unique attributes address some of the challenges faced by the traditional music industry, such as declining revenue from physical album sales.

In my view, NFTs bring a much-needed transformation to the music industry, opening up a world of possibilities for artists, labels, and fans alike. As we continue to explore this exciting space, I'm eager to see how NFTs will reshape the industry and redefine how we all experience and connect with music.

Artists and labels can create digital collectibles in the form of NFTs, which can include album covers, limited-edition artwork, or animated visuals. These collectibles can be bought, sold, and traded on various NFT marketplaces, enabling fans to own a piece of digital memorabilia that can appreciate in value over time.

NFTs can also be used to represent fractional ownership of music rights or royalties, allowing artists and labels to sell shares in their work to fans and investors. This innovative approach provides creators with immediate funding and a long-term revenue stream, while offering fans and investors a stake in the success of the music.

1.3. Analyzing Successful NFT Music Releases

The potential of NFTs in the music industry has been demonstrated through numerous successful releases and collaborations:

Electronic musician 3LAU's $11.6 million NFT album sale exemplified the value that fans and collectors place on unique digital assets. This

model could pave the way for other artists to release albums as NFTs, unlocking new revenue streams and potential appreciation in value.

Kings of Leon's innovative approach of offering three different token types for their album release demonstrated the potential of NFTs to tap into multiple revenue streams and engage fans in unique ways. This strategy can be adopted by other artists and labels to monetize various aspects of their work.

The collaboration between DJ and producer Steve Aoki and visual artist Antoni Tudisco showcased the creative potential of NFTs in the music industry. By combining music and visual art, artists can explore new mediums of expression and reach a wider audience.

1.4. Evaluating the Advantages of NFTs for Artists and Labels

NFTs offer a range of benefits for artists and labels in the music industry, presenting new opportunities for monetization, fan engagement, and creative expression.

NFTs provide artists and labels with new revenue streams through sales of digital collectibles, limited-edition releases, and exclusive experiences. This allows them to diversify their income sources and capitalize on the growing demand for unique digital assets.

Blockchain technology guarantees the provenance and authenticity of NFTs, protecting artists and labels from piracy and unauthorized distribution. This ensures that the value of their work is maintained and that fans can trust the origin of the digital assets they purchase.

NFTs offer fans unique and exclusive opportunities to connect with their favorite artists, fostering loyalty and deepening the artist-fan

relationship. This can lead to increased engagement, long-term support, and higher revenue for artists and labels.

NFTs can include built-in royalty mechanisms that ensure artists and labels receive a percentage of future resales, creating a long-term revenue stream. This enables creators to benefit from the ongoing success of their work, even after the initial sale.

NFTs enable artists and labels to push the boundaries of creativity by combining music with other forms of digital art and experiences, opening up new avenues for artistic expression. This can lead to innovative collaborations, unique releases, and a more diverse music landscape.

Examples of blockchain projects in the music industry:

- Musicoin[1]: a platform that allows musicians to get paid directly from fans.
- Mycelia[2]: a project led by musician Imogen Heap, working to create a decentralized music ecosystem using blockchain technology.
- eMusic[3]: operates as a music distribution and royalty management platform that rewards artists and fans.
- BitSong[4]: a global music community with a trustless marketplace for music streaming, Fan Tokens, and NFTs powered by the BTSG token.
- Audius[5] : a decentralized music streaming platform that allows musicians to share their music and directly connect with their

1. https://musicoin.org/

2. http://myceliaformusic.org/

3. https://token.emusic.com/

4. https://bitsong.io/

5. https://audius.org/

fans.

The rise of NFTs in the music industry offers an exciting new frontier for artists, labels, and fans. Understanding the technology and landscape is crucial for anyone looking to launch an NFT music label. By recognizing the potential of NFTs and learning from successful examples, you can capitalize on this growing trend and create a thriving NFT music label that stands out in the competitive music industry. As you progress through the following chapters, you'll gain the knowledge and insights necessary to navigate the unique challenges and opportunities that NFTs present, setting the foundation for your own successful NFT music label venture.

Chapter 2: Planning Your NFT Music Label

2.1. Defining Your Label's Mission and Vision

Before launching your NFT music label, it's essential to establish a clear mission and vision that reflect your label's purpose, values, and long-term aspirations.

Your mission statement should outline the core purpose of your label and highlight the unique value proposition you aim to provide for artists and fans in the context of NFTs. Consider how your label will leverage the benefits of NFTs, such as innovative monetization methods, fan engagement opportunities, and creative freedom. Your mission might focus on empowering artists through blockchain technology or promoting music and digital art fusion through NFTs.

Your vision should depict the long-term aspirations of your label, providing a clear direction for growth and success. This might involve becoming a leading label for cutting-edge NFT music releases, pioneering new blockchain-based solutions for the music industry, or cultivating a diverse, global community of artists and fans connected through NFTs.

2.2. Identifying Your Target Market and Niche

To differentiate your NFT music label from competitors and connect with a loyal audience, it's essential to identify a specific target market and niche within the music industry.

This niche could be based on genre, style, or even a particular theme or concept that resonates with your target audience. Alternatively, you may choose to focus on a specific aspect of NFT technology, such as

tokenizing music rights, developing innovative royalty mechanisms, or creating immersive, interactive experiences for fans.

Research your chosen niche and understand the preferences and expectations of your target market. Gather data on demographics, interests, and consumer behavior patterns, and use this information to tailor your marketing efforts and NFT offerings to maximize appeal and engagement.

2.3. Setting Short-term and Long-term Goals

Establishing measurable and realistic goals is critical for tracking your label's progress and ensuring long-term success.

Break down your goals into short-term (e.g., 6-12 months) milestones, such as signing your first artist, minting your initial NFT collection, generating a specific amount of revenue, or establishing partnerships with key industry players.

Develop long-term (e.g., 3-5 years) objectives, such as expanding your artist roster, achieving a certain market share within your niche, exploring new NFT-related technologies and opportunities, or establishing your label as a thought leader in the blockchain and music space.

2.4. Creating a Business Plan

A well-crafted business plan serves as a roadmap for your NFT music label and helps attract potential investors, partners, and collaborators.

2.4.1. Executive Summary

Briefly overview your label's mission, vision, target market, and competitive advantages. This summary should concisely convey the

unique aspects of your label and its potential for success in the NFT music landscape.

2.4.2. Market Analysis

Conduct a detailed examination of the music industry, your niche, and the competitive landscape. This analysis should include trends in NFT adoption, the growth of blockchain technology in the music sector, and potential market opportunities and threats.

2.4.3. Marketing Strategy

Develop a comprehensive plan for promoting your label and NFT offerings, including branding, social media, PR, and partnerships. Consider how to leverage influencers, industry events, and content marketing to reach your target audience and establish your label's presence in the NFT music space.

2.4.4 Financial projections

A realistic assessment of your label's projected income, expenses, and growth over the next 3-5 years.

By addressing these crucial aspects in your business plan, you'll have a solid foundation to guide your NFT music label's growth and development, ensuring you're well-prepared for the challenges and opportunities that lie ahead.

Chapter 3: Building Your Team

3.1. Roles and Responsibilities in an NFT Music Label

An effective NFT music label requires a diverse team with a wide range of skills and expertise. Key roles and responsibilities within an NFT music label include:

Label Owner/CEO

The label owner or CEO oversees the overall direction and management of the label, makes strategic decisions, and ensures the label's vision is being pursued. This individual should have a strong understanding of the music industry, NFT technology, and business management.

A&R (Artists and Repertoire) Manager

The A&R manager discovers and signs new talent, works closely with artists to develop their careers, and manages artist-label relationships. They should have an extensive network within the music industry and a keen eye for identifying promising talent that aligns with the label's vision.

Music Producer

The music producer collaborates with artists to create, arrange, and produce music tracks, ensuring they align with the label's vision and standards. This role requires strong musical and technical skills and the ability to work closely with artists to bring their creative visions to life.

Visual Artist/Graphic Designer

The visual artist or graphic designer designs and creates visual assets for NFT releases, album artwork, and promotional materials. This

individual should have a strong background in digital art and design, with an understanding of the unique visual requirements for NFTs.

Blockchain Developer/Technical Advisor

The blockchain developer or technical advisor provides expertise on blockchain technology, assists in the NFT minting process, and ensures the label's digital assets are secure and functional. This role requires in-depth knowledge of blockchain platforms, smart contracts, and relevant programming languages.

Marketing Manager

The marketing manager develops and executes marketing strategies, manages social media accounts, and promotes the label's NFT releases and artists. This individual should be well-versed in digital marketing, content creation, and public relations, with an understanding of how to effectively promote NFTs and engage the target audience.

Legal Advisor

The legal advisor offers guidance on legal matters related to intellectual property, contracts, and licensing, ensuring the label's operations comply with relevant laws and regulations. This role requires a strong background in entertainment law, with a focus on the unique legal aspects of NFTs and the music industry.

3.2. Finding and Attracting Talent

First things first, think about the roles you need to fill. You'll need artists, producers, marketing pros, tech wizards, and more. Knowing what you need will make it easier to find the right people.

Next, get out there and mingle! Hit up music and blockchain events, and chat with people who share your interests. You never know whom you'll meet or what ideas you'll come up with together.

Don't forget about the internet, either. LinkedIn is a great place to find people with the skills you need. Just use filters to narrow down your search and send personalized messages to connect with potential team members.

You should also reach out to your own network of friends and colleagues. They might know someone perfect for your team. And speaking of connections, try partnering with schools or institutions that focus on music and blockchain. They could have talented students or alumni looking for opportunities like yours.

Building a team is an ongoing process, so keep your eyes open for new talent as your label grows. And remember, a strong company culture and a supportive environment will help you attract and keep the best people.

By following these steps and staying engaged, you'll be on your way to creating a fantastic team for your NFT music label.

3.2.1. Showcasing Your Label's Vision

Attracting talented individuals requires showcasing your label's vision and demonstrating how their skills and expertise can contribute to the label's success. Offer competitive compensation packages, create a supportive work environment, and highlight the unique opportunities provided by working with an innovative NFT music label.

Develop a proactive approach to talent acquisition by cultivating a pipeline of potential candidates, even before specific roles become available. This can involve staying connected with industry professionals, tracking their career progress, and establishing relationships with potential future team members.

3.3. Building Partnerships and Collaborations

In addition to your core team, building partnerships and collaborations with industry professionals and organizations can greatly enhance your label's reputation and reach.

3.3.1. Music Distributors

Forge strong relationships with digital music distribution platforms to guarantee that your label's releases reach the widest audience possible. Negotiate distribution deals and explore various opportunities, such as featuring your artists on curated playlists, offering exclusive content, and creating co-branded marketing campaigns to increase your label's exposure and draw in new fans.

3.3.2. NFT Marketplaces

Establish collaborations with reputable NFT marketplaces to showcase and sell your label's NFT releases. By building solid relationships with these platforms, you can secure promotional support, special features, and exclusive collaborations that will elevate your label's visibility and sales. Stay updated on emerging NFT platforms and trends to ensure your label remains at the forefront of innovation.

3.3.3. Streaming Platforms

Form strategic partnerships with streaming services to amplify your artists' music promotion and enhance their visibility. These partnerships help your label reach new audiences and generate additional revenue streams through streaming royalties. Consider offering exclusive content, such as live performances, interviews, or behind-the-scenes footage, to create a unique experience for your listeners and strengthen your relationship with streaming platforms.

3.3.4. PR Agencies

Collaborate with PR agencies to produce engaging media coverage and generate buzz around your label and NFT releases. A well-executed PR campaign can elevate your label's profile, attract new fans, and secure valuable industry partnerships, such as sponsorship deals or event collaborations. Choose a PR agency with experience in the music and blockchain industries to ensure they can effectively communicate your label's unique value proposition.

3.3.5. Influencers

Team up with influencers in your niche to promote your label and NFT offerings to their followers. Influencer marketing can be a highly effective method for reaching a broader audience and sparking interest in your artists and NFT releases. Identify influencers who share your label's values and aesthetic, and develop creative campaigns that showcase your music and NFT offerings in an authentic and engaging manner. This could include sponsored posts, giveaways, or even co-creating content that resonates with the influencer's audience.

3.4. Creating a Rockstar Company Culture

You know what really makes a difference for a successful NFT music label? A kick-ass company culture! It's the secret sauce that brings your team together, keeps everyone motivated, and helps you hang onto your top talent.

3.4.1. Share the Dream

First, make sure everyone's on the same page. Talk about your mission and vision in a way that really resonates with your team. When they can see how their work contributes to the big picture, they'll feel united and driven to make things happen.

3.4.2. Teamwork Makes the Dream Work

Encourage collaboration and open communication so your team members feel like they're part of a supportive tribe. Set up brainstorming sessions, cross-functional projects, and other opportunities for your team to learn from each other and grow together. When everyone feels heard and valued, you're creating a culture that's unstoppable.

3.4.3. Celebrate the Wins (and Learn from the Losses)

Take the time to recognize and celebrate your team's achievements, whether they're big or small. This positive reinforcement will keep morale high and inspire everyone to keep up the good work. And when things don't go as planned, use those experiences as valuable learning opportunities.

3.4.4. Help Your Team Level Up

Want to show your team you're invested in their success? Offer professional development opportunities that help them sharpen their skills and advance their careers. This can be anything from training programs to mentorship or resources for self-improvement. When your team members feel supported in their growth, they'll be more committed to your label's success.

3.4.5. Embrace the Rainbow

Don't forget the power of diversity and inclusion. By creating an environment that welcomes people from all walks of life, you'll tap into a wealth of ideas and perspectives that can take your label to new heights. Make sure everyone has equal opportunities to grow and contribute, and you'll cultivate a culture that's as inclusive as it is innovative.

By focusing on these aspects of your company culture, you'll build a dream team ready to take the NFT music world by storm. So go ahead,

create the culture that excites people to come to work every day, and watch your label thrive!

Chapter 4: Legal and Financial Considerations

Choosing the right legal structure Selecting the appropriate legal structure for your NFT music label is essential for protecting your personal assets, ensuring regulatory compliance, and maximizing tax benefits. Common legal structures include sole proprietorships, partnerships, limited liability companies (LLCs), and corporations. Consult with a legal professional to determine which structure best suits your label's needs and objectives.

Intellectual property and NFT licensing Intellectual property (IP) protection is crucial in the NFT music industry to safeguard your artists' work and your label's assets. Ensure that you have proper IP agreements in place, including copyrights for musical compositions and sound recordings and trademarks for your label's name and logo.

In the context of NFTs, it's important to establish clear licensing terms that outline the rights and restrictions for NFT buyers. This may include limitations on commercial use, reproduction, or distribution of the music associated with the NFT. Collaborate with a legal advisor to draft licensing agreements that protect your artists' interests and comply with applicable laws.

Budgeting and financial management Effective financial management is critical for the sustainability and growth of your NFT music label. Develop a detailed budget that includes projected revenues, expenses, and cash flow. Regularly review and update your budget to ensure you stay on track and make informed financial decisions.

Key financial aspects to consider include:

- Production costs: Allocate funds for music production, NFT

creation, and minting expenses.

- Marketing and promotion: Budget for advertising, PR, social media, and other promotional activities.
- Operating expenses: Account for ongoing costs such as rent, utilities, and employee salaries.
- Legal and accounting fees: Set aside funds for professional services related to legal matters, taxes, and financial reporting.

Tax implications and reporting requirements As a business owner, it's crucial to understand the tax implications of your NFT music label and adhere to all reporting requirements. This may involve collecting sales tax, reporting income from NFT sales, and filing annual tax returns.

In addition, the regulatory landscape surrounding NFTs and cryptocurrencies is continually evolving, and it's essential to stay informed of any changes that may impact your label's operations. Consult with a tax professional to ensure you're in compliance with all relevant tax laws and regulations.

By addressing these legal and financial considerations, you'll establish a solid foundation for your NFT music label and minimize potential risks, allowing you to focus on growing your business and achieving your goals.

Don't miss out on the opportunity to jump-start your music business with the selection of forms and contracts for the music industry. This toolbox includes NFT-related sample contracts and more that can help you launch your record label quickly and easily. Take advantage of this comprehensive resource today by clicking on this link: https://tferriere.gumroad.com/l/contracts

Chapter 5: Creating and Minting NFTs

5.1. Selecting the right Blockchain platform

5.1.1. Ethereum

Ethereum is the most widely-used platform for creating and trading NFTs. It supports the ERC-721 and ERC-1155 token standards, which are the most common NFT standards. While Ethereum offers a large user base and extensive developer support, it suffers from high gas fees and network congestion. Popular tools for working with Ethereum NFTs include OpenZeppelin, Remix, and Truffle Suite.

5.1.2. Binance Smart Chain

Binance Smart Chain (BSC) is a more cost-effective alternative to Ethereum, with faster transaction speeds and lower gas fees. BSC supports the BEP-721 and BEP-1155 token standards, which are compatible with their Ethereum counterparts. However, BSC is more centralized than Ethereum, which may be a concern for some users. Tools like PancakeSwap and Anyswap can help with BSC NFT creation and trading.

5.1.3. Solana

Solana is a high-performance blockchain platform that offers low gas fees and fast transaction times. It uses the SPL token standard for NFTs, which is unique to the Solana ecosystem. While Solana is gaining popularity, it has a smaller user base and developer community than Ethereum. Metaplex is a popular tool for creating and managing Solana NFTs.

5.2. Minting process and associated costs

5.2.1. Smart contracts

To mint NFTs, you'll need to create a smart contract on your chosen blockchain platform. This contract defines the properties of the NFT, such as its metadata, supply, and royalties. Work with your blockchain developer to create a secure and efficient smart contract that adheres to the platform's specific token standard. Tools like Solidity and Rust can be used for developing smart contracts on Ethereum and Solana, respectively.

5.2.2. Metadata and storage

NFT metadata contains information about the digital asset, such as the title, creator, and a link to the actual content (e.g., an audio file or image). This content is usually stored off-chain on decentralized storage platforms like IPFS or Arweave, which provide secure and permanent storage solutions. Ensure that your metadata and storage methods are robust and reliable to maintain the integrity and accessibility of your NFTs.

5.3. Designing unique and engaging NFTs

Allright, let's take your NFT music label to the next level! You'll want to create an unforgettable, immersive experience for your audience that blends music and visuals in a way that's downright magical.

Start by teaming up with your music producers and visual artists. Get them working together like peanut butter and jelly, combining their talents to create a seamless fusion of high-quality audio and eye-catching artwork. You'll be crafting a memorable experience that leaves your audience begging for more.

But why stop there? Let's make things even more exciting by adding interactive elements and gamification to your NFTs. Think about including unlockable content, brain-teasing puzzles, or challenges that get users hooked on engaging with your NFTs on a deeper level. These features boost the value of your NFTs and create a sense of exclusivity that collectors will go nuts for.

To bring your interactive and gamified NFT experiences to life, consider using powerful tools like Unity and Unreal Engine. With these platforms at your fingertips, you can create cutting-edge experiences that'll have people talking about your label for days.

So there you have it! By blending music, visuals, and interactive elements, you're not just creating NFTs but crafting experiences that capture hearts and minds. Get ready to make some serious waves in the NFT music world!

5.3.1 A Shortcut to Boosting Your Record Label's Uniqueness and Attracting Fans: Create NFTs at Lightning Speed!

NFTs, or non-fungible tokens, are digital certificates that can establish ownership and provenance of art or music on the blockchain, making them unique and valuable.

In this chapter, we'll show you how to easily create an NFT for music.

Step 1: Select your platform.

When selecting an NFT platform, finding one that aligns with your specific goals, budget, management capabilities, and ease of use is crucial. OpenSea, for instance, operates on the Ethereum blockchain, which is known for its scalability, security, and smart contract capabilities. Rarible, on the other hand, uses the Rarible Protocol, a custom smart contract for creating and trading NFTs, which enables sellers to benefit

from a lower fee structure. SuperRare is another platform that runs on the Ethereum blockchain, but it is geared toward higher-end art collections and has stricter curation standards for creators. By understanding the blockchains that underpin each NFT platform, you can better evaluate which one will suit your needs and help launch your record label in the NFT marketplace.

Step 2: Create Your Account.

After selecting your platform, you need to create an account. Follow the basic signup process by providing your name and email address, which is then verified through your email.

Step 3: Connect Your Wallet to the Platform.

To create an NFT, you need to connect your digital wallet to the chosen platform. Use wallets like MetaMask, Trust Wallet, or Fortmatic to buy and sell NFTs. Connecting your wallet to the platform is typically straightforward.

Step 4: Upload Your Artwork and Music.

You can upload your artwork and music with your wallet linked to the platform. Uploading diverse art and music collections by multiple artists can help increase the value of the NFTs. Before uploading, check the platform's guidelines on file types, sizes, and formats to avoid any setbacks. Add descriptions of your unique collections, highlighting the artists and sub-genres.

Step 5: Set the Value of Your NFT.

NFTs' value is based on different factors, including the rarity, quality, and artists' popularity. Set an attractive and reasonable price that reflects the potential worth of the NFTs. Offer bulk purchase options or bundle them with special merch or event access to increase their value.

Step 6: Mint Your NFT.

After setting the price, mint your NFT by creating a digital certificate that verifies ownership of your artwork and music. With the NFTs minted, each one should have unique properties such as limited edition or rare ownership certificates. Set unique properties for NFTs to allow your record label's fans to showcase their ownership and add to their uniqueness.

Step 7: List Your NFT for Sale.

Finally, list your NFTs for sale on the platform's marketplace. Promote them on social media channels or fan websites for better exposure. Reach out to customers and offer them perks like media or merchandise, live chats with artists or signed memorabilia, and access to exclusive album releases or concerts.

Follow these seven steps to create and sell your NFTs, and make them unique by minting exclusive properties and listing them on the right platforms. Don't hesitate to reach out to potential customers and offer them special perks or giveaways to broaden your fan base.

5.4. Ensuring authenticity and provenance

5.4.1. Blockchain verification

Ensure that your NFTs are properly minted and registered on the blockchain, with accurate metadata and links to the original content. This allows users to verify the authenticity and provenance of your NFTs by checking their blockchain records.

5.4.2. Licensing and rights management

Work with your legal advisor to establish clear licensing agreements and rights management for your NFTs. This includes specifying NFT holders' rights, such as usage, distribution, and resale. By clearly defining these terms, you can protect your artists' intellectual property and maintain control over the use and distribution of their work.

If you're ready to start your journey into the music industry and want a complete toolbox that includes NFT-related sample contracts, check out the selection of forms and contracts for the music business. With these tools, opening your record label becomes much more straightforward and efficient. Click the link to get started: https://tferriere.gumroad.com/l/contracts

By mastering the process of creating and minting NFTs, your label will be well-equipped to capitalize on the growing popularity of NFTs in the music industry and provide unique, valuable digital assets to your artists and their fans. Utilizing popular tools and platforms will help streamline the creation process, enhance the quality of your NFT offerings, and ensure a seamless experience for both creators and collectors.

Chapter 6: Marketing and Promotion Strategies

6.1. Branding your NFT music label

Alright, let's dive into crafting a brand story that'll make your NFT music label stand out from the pack. You want a narrative that captures your label's essence, highlights what sets you apart from the competition, and makes your audience sit up and take notice.

First, let's pinpoint your label's unique selling points. Maybe you're revolutionizing how artists monetize their work, or perhaps you're empowering artists to take control of their careers. Whatever it is, make sure your narrative sings with the spirit of what makes your label exceptional.

Now, you don't want to be all talk and no show. Consistency is key when it comes to your visual and verbal identity. Whether it's the tone of voice in your blog posts, the look of your social media profiles, or the design elements in your promotional materials – everything should be cohesive and unmistakably "you."

But how can you make sure your brand is consistent across all channels?

Here are a few tips:

- Develop a brand style guide: This handy document will outline your label's visual and verbal guidelines, including colors, fonts, logo usage, and even writing style. Share it with your team to ensure everyone's on the same page.
- Create brand templates: Whip up some pre-designed templates for social media, blog posts, and other marketing materials. This way, you'll have a consistent look and feel without

reinventing the wheel every time you create something new.

- Be mindful of your tone: It's not just about the visuals – your label's voice should also be consistent across all written content. Keep your tone in line with your brand personality, whether it's casual, authoritative, or something in between.
- Review and refine: Regularly take a step back and evaluate your brand's consistency. Are there any gaps or inconsistencies? If so, tweak and adjust as needed to keep everything on point.

Creating a compelling brand narrative and maintaining consistency across all channels will establish a strong presence that resonates with your audience and sets your NFT music label apart from the rest.

6.2. Social media marketing and community building

Tailor your social media marketing efforts to each platform's unique features and user demographics. For example, use Instagram to showcase visually appealing NFT artwork and behind-the-scenes content while leveraging Twitter for real-time updates and engagement with fans.

Monitor your social media analytics to identify which types of content resonate most with your audience. Use this data to refine your content strategy, focusing on the formats, topics, and posting frequencies that generate the most engagement and growth.

6.3. Influencer and artist collaborations

Alright, let's talk about how to make your NFT music label the talk of the town! One of the best ways to create buzz and boost visibility is by joining forces with influencers and established artists to create some seriously cool co-branded NFT collections. You'll be merging their

creative genius with your label's distinct branding, and trust me; people will take notice.

Picture this: You partner up with a chart-topping electronic music artist to create a limited-edition NFT collection. It features mind-blowing remixes of their tracks that you can't find anywhere else, plus custom artwork that's a perfect blend of their style and your label's visual identity. Collectors will be lining up around the block (virtually, of course) to snag these one-of-a-kind NFTs, and your label will enjoy a surge in visibility.

But don't stop there! Let's take things up a notch by inviting influencers or artists to "take over" your label's social media accounts for a day. They'll share exclusive content, dish out insights into their creative process, and engage with fans like they're old pals. This'll create a sense of community around your label and drive new followers to your social media channels, making your label even more of a hot commodity.

Here are a few more tips to make these collaborations even more successful:

- Choose the right partners: Look for influencers and artists who share your label's values and resonate with your target audience. A strong alignment will make your collaboration more authentic and appealing to fans.
- Promote, promote: Hype up your collaborations with teasers, countdowns, and behind-the-scenes content on social media. Build anticipation and excitement, so your audience can't wait to see what you've got up your sleeve.
- Track your success: Keep an eye on the impact of your collaborations. Analyze engagement, new followers, and NFT sales to see what's working and what could be improved for future partnerships.

Collaborating with influencers and established artists will create a buzzworthy fusion of creativity and branding that puts your NFT music label in the spotlight. Get ready to watch your label soar to new heights!

6.4. PR and media outreach

Let's talk about generating buzz for your NFT music label that'll have the media eating out of the palm of your hand. You want to create compelling story angles that'll have journalists and media outlets scrambling to cover your label and NFT releases. Here's how to make that happen.

First, hone in on the unique aspects of your label that'll make everyone sit up and take notice. Maybe you've got some ground-breaking tokenomics, partnerships with A-list artists, or charitable initiatives that give back through your NFT sales. Whatever it is, make sure your pitch highlights these attention-grabbing details.

But why stop with just pitching stories? Let's go one step further and organize or sponsor events that'll have the media buzzing about your label. Think virtual concerts that get fans dancing in their living rooms, panel discussions with industry thought leaders, or NFT art exhibitions that showcase the incredible talent of your artists.

These events aren't just about grabbing headlines; they're also golden opportunities for networking, engaging with fans, and displaying your label's artists and NFT collections for the world to see.

Here are a few tips to make your events and media pitches even more successful:

- Timing is everything: When pitching to media outlets, consider the news cycle and tailor your pitch to fit current trends and interests. This way, you're more likely to catch their

attention and secure coverage.

- Be selective: Target media outlets that align with your label's values and audience. A tailored pitch to a relevant outlet has a much better chance of success than a generic pitch sent to dozens of publications.
- Engage your audience: For your events, make them interactive and engaging. Encourage audience participation, run contests, or provide exclusive content to create memorable experiences that leave a lasting impression.
- Amplify your impact: Promote your events and media coverage across your social media channels, email newsletters, and website. This drives more attention to your label and reinforces your credibility and authority in the industry.

By crafting irresistible story angles and organizing buzz-worthy events, the media will swoon over your NFT music label and be eager to share your story with the world. It's time to take center stage and show them what you're made of!

6.5. Email marketing and direct communication

Let's talk about how to establish a direct line of communication with your fans and collectors that'll have them eagerly awaiting your every update. With the power of email marketing, you can share news, exclusive content, and promotional offers that'll keep them coming back for more and drive traffic to your NFT releases and events.

First things first: Build your email list by collecting email addresses from your fans and collectors. Whether it's through your website, social media, or live events, give them a reason to sign up – think exclusive content, sneak peeks, or special offers they won't want to miss.

Now, let's not just send generic, one-size-fits-all emails. Instead, segment your email list based on factors like user behavior, preferences, and purchase history. Personalizing email content will increase engagement and conversion rates, making your audience feel seen and valued.

Here's how you can get the most out of your email marketing:

1. Be relevant: Target specific segments with news, offers, and recommendations that matter to them. This way, you're more likely to pique their interest and keep them engaged with your label.
2. Strike the right balance: Don't bombard your subscribers with emails, but also don't let them forget you exist. Find the sweet spot between staying top-of-mind and respecting their inbox.
3. Test and optimize: Regularly analyze your email marketing performance, looking at open rates, click-through rates, and conversions. Use these insights to optimize your campaigns and make data-driven decisions.
4. Leverage automation: Use email marketing tools to automate campaigns, segment your list, and personalize content. This saves you time and ensures you're delivering the right message to the right person at the right time.

By implementing these advanced marketing and promotion strategies, your NFT music label will effectively engage and expand its audience, making waves in the competitive NFT market. Get ready to see your label's visibility and success soar to new heights!

Chapter 7: NFT Sales and Monetization

7.1. Primary and secondary markets for NFTs

Plan the timing of your NFT releases to maximize exposure and demand. Consider coordinating releases with major events, album launches, or seasonal trends to capitalize on increased interest. Develop a staggered release strategy for limited-edition NFT collections, creating a sense of urgency and exclusivity.

Promote your NFTs on secondary markets by engaging with collectors, sharing news about upcoming NFT drops, and showcasing the success of previous releases. Encourage satisfied collectors to share their experiences; positive testimonials can drive interest and credibility.

7.2. Pricing strategies for NFT releases

Experiment with dynamic pricing models, which adjust prices based on factors such as market demand, collector behavior, or the performance of previous releases. This approach can help optimize revenue generation while maintaining interest in your NFTs.

Offer bundles or discounts for purchasing multiple NFTs, incentivizing collectors to invest in a larger portion of your label's offerings. This strategy can encourage long-term engagement and support while increasing overall sales.

7.3. Revenue sharing and royalties

Design flexible royalty structures to accommodate different levels of contributions from artists, collaborators, and other stakeholders. This may include different royalty percentages for primary sales versus secondary sales or tiered royalty rates based on sales milestones.

Incorporate performance-based incentives into revenue-sharing agreements, rewarding artists for the success of their NFTs. For example, artists could receive bonus payouts if their NFTs achieve specific sales targets or reach a certain level of popularity.

7.4. Exploring additional monetization opportunities

Issue NFT-backed fan tokens that provide holders with voting rights on label decisions, such as artwork choices or upcoming collaborations. This creates a sense of community and ownership while driving additional revenue from token sales.

Integrate gamification elements into your NFT offerings, such as challenges, quests, or leaderboards that reward collectors with exclusive content or status. Gamification can increase engagement, encourage repeat purchases, and create a unique collector experience.

Leverage the intellectual property associated with your NFTs for licensing opportunities, such as merchandise, video games, or film adaptations. Licensing deals can generate additional revenue streams and broaden your label's reach.

By implementing a comprehensive sales and monetization strategy, your NFT music label will maximize revenue, attract artists and collectors, and ensure long-term sustainability in the competitive NFT market.

Chapter 8: Supporting Artists and Fostering Growth

Let me share some key strategies for building a thriving NFT music label that'll stand the test of time. By investing in your artists, nurturing their growth, and staying ahead of the curve, you'll create a powerhouse label that'll be the envy of the industry.

1. Focus on artist development and mentorship: Your label's long-term success hinges on the talent you nurture. Provide resources, guidance, and support to help your artists hone their skills, expand their networks, and build their personal brands. Connect them with industry experts, organize workshops or masterclasses, and offer constructive feedback on their work. By empowering your artists, you'll cultivate a roster of top-notch talent that'll succeed in the cutthroat NFT music market and remain loyal to your label.

2. Create a supportive and creative environment: Nothing fuels collaboration, innovation, and artistic growth like a positive, nurturing atmosphere. Encourage open communication and idea-sharing among your artists, team members, and partners. Cultivate a culture that values experimentation and risk-taking, celebrating both successes and the lessons learned from failures. This kind of environment will attract and retain top talent, resulting in high-quality NFT releases and a vibrant label identity.

3. Expand your label's portfolio and reach: As your NFT music label grows, seize opportunities to diversify your portfolio and captivate new audiences. Consider signing artists from different genres or backgrounds, exploring international markets, or launching sub-labels catering to specific niches. By diversifying your roster and venturing into new markets, you'll

boost your label's visibility, appeal to a wider range of collectors and fans, and generate additional revenue streams.

4. Stay ahead of industry trends and innovations: The NFT music industry is a fast-moving beast, and keeping your finger on the pulse is crucial for your label's continued relevance and success. Stay informed by monitoring industry news, attending conferences and events, and networking with other professionals. Keep a close eye on emerging technologies, platforms, and consumer preferences.

5. Be adaptable and agile: Adopt a flexible approach to your label's strategy and operations, and be ready to pivot or adapt to changes in the market. Embracing innovation and staying agile will help ensure your NFT music label remains at the forefront of the industry.

By supporting your artists, fostering their growth, and adapting to the ever-changing NFT music landscape, you'll create a thriving, sustainable label that is well-positioned for long-term success. Remember, it's not just about building a label—it's about cultivating a legacy.

Conclusion

Launching a successful NFT music label requires careful planning, strategic execution, and a deep understanding of the evolving music and NFT industries. By following the key steps outlined in this guide, you will be well-equipped to navigate the challenges and opportunities presented by this exciting new frontier.

Recap of key steps to launching a successful NFT music label:

1. Understanding NFTs and the Music Landscape
2. Planning Your NFT Music Label
3. Building Your Team
4. Legal and Financial Considerations
5. Creating and Minting NFTs
6. Marketing and Promotion Strategies
7. NFT Sales and Monetization
8. Supporting Artists and Fostering Growth

Embarking on this journey as an NFT music label founder offers the potential to revolutionize the way we create, share, and monetize music while empowering artists and providing unique experiences for collectors and fans.

As you venture into this rapidly growing market, remember to stay agile, embrace innovation, and always prioritize the well-being and development of your artists. By doing so, you'll contribute to the music industry's ongoing evolution and help shape its future for years to come.

Best of luck as you embark on this exciting new endeavor!

Glossary of Key Terms

1. NFT (Non-Fungible Token) - A unique digital asset that represents ownership or proof of authenticity for a specific item or piece of content, such as art, music, or collectibles, stored on a blockchain.
2. Blockchain - A decentralized digital ledger that records transactions across multiple computers, ensuring the data is secure and transparent.
3. Smart Contract - A self-executing contract with the terms of the agreement directly written into code, which is stored and executed on a blockchain.
4. ERC-721 - A widely-used token standard for creating non-fungible tokens (NFTs) on the Ethereum blockchain.
5. ERC-1155 - A token standard that allows for the creation of both fungible and non-fungible tokens on the Ethereum blockchain.
6. BEP-721 - A token standard for creating non-fungible tokens (NFTs) on the Binance Smart Chain.
7. BEP-1155 - A token standard that allows for the creation of both fungible and non-fungible tokens on the Binance Smart Chain.
8. SPL - A token standard for creating non-fungible tokens (NFTs) on the Solana blockchain.
9. Gas Fees - Fees paid by users to compensate for the computational resources required to process and validate transactions on a blockchain network, such as Ethereum.
10. IPFS (InterPlanetary File System) - A decentralized, peer-to-peer network for storing and sharing data in a distributed file system.
11. Arweave - A decentralized storage network that provides permanent and secure data storage on a blockchain-based

platform.

12. Metadata - Information about a digital asset (such as an NFT) that describes its content, creator, and other relevant details.

13. Royalties - A percentage of revenue paid to artists or creators when their work is sold, licensed, or otherwise monetized.

14. Primary Market - The initial sale of NFTs directly from the creator or a label to collectors or fans.

15. Secondary Market - The marketplace where collectors and fans can buy, sell, or trade NFTs among themselves after the initial sale.

16. Minting - The process of creating a new NFT and registering it on the blockchain.

17. Provenance - The documented history of ownership, authenticity, and origin of a digital asset, such as an NFT, which can be verified on a blockchain.

18. Decentralized - A system or network that operates without a central authority, distributing control and decision-making among multiple participants.

19. Token Standard - A set of rules and guidelines for creating tokens on a blockchain platform, ensuring compatibility and interoperability.

20. Licensing Agreement - A legal contract that specifies the terms under which one party can use the intellectual property (such as music or artwork) of another party.

Chapter 8: Recommended Resources and Tools

8.1. NFT Marketplaces Here are some popular NFT marketplaces where you can launch and sell your music NFTs:

1. OpenSea (https://opensea.io[1]) - The largest NFT marketplace, supporting Ethereum and Polygon blockchains.
2. Rarible (https://rarible.com[2]) - A user-friendly NFT marketplace and platform for creating and selling NFTs on Ethereum.
3. Foundation (https://foundation.app[3]) - A curated NFT platform for artists and musicians, supporting Ethereum blockchain.
4. SuperRare (https://superrare.com[4]) - A high-end, curated NFT platform focused on digital art and music, built on Ethereum.
5. Solsea (https://solsea.io[5]) - A popular NFT marketplace on the Solana blockchain.

8.2. NFT Creation and Minting Tools These tools can help you create, mint, and manage your music NFTs:

1. Mintbase (https://mintbase.io[6]) - A platform for creating, minting, and managing NFTs on Ethereum and NEAR

1. https://opensea.io/

2. https://rarible.com/

3. https://foundation.app/

4. https://superrare.com/

5. https://solsea.io/

6. https://mintbase.io/

Protocol.

2. Cargo (https://cargo.build[7]) - A platform for creating, minting, and managing ERC-721 and ERC-1155 NFTs on Ethereum.
3. Metaplex (https://metaplex.com[8]) - A platform for creating and managing NFTs on the Solana blockchain.

8.3. Decentralized Storage Solutions These decentralized storage solutions can help store your NFT content securely:

1. IPFS (https://ipfs.io[9]) - A decentralized, peer-to-peer network for storing and sharing data.
2. Arweave (https://arweave.org[10]) - A decentralized storage network for permanent and secure data storage on a blockchain-based platform.
3. Filecoin (https://filecoin.io[11]) - A decentralized storage network built on IPFS, which uses a market-driven approach to allocate storage resources.

8.4. Smart Contract Development Tools and resources for developing and deploying smart contracts on various blockchains:

1. Remix IDE (https://remix.ethereum.org[12]) - A powerful, open-source development environment for Ethereum smart contracts.

7. https://cargo.build/

8. https://metaplex.com/

9. https://ipfs.io/

10. https://arweave.org/

11. https://filecoin.io/

12. https://remix.ethereum.org/

2. Truffle Suite (https://www.trufflesuite.com[13]) - A development environment, testing framework, and asset pipeline for Ethereum and other blockchain platforms.
3. Hardhat (https://hardhat.org[14]) - A development environment for Ethereum, featuring a built-in debugger and testing framework.

8.5. Legal and Licensing Resources Resources for understanding legal and licensing aspects of NFTs and digital assets:

1. Creative Commons (https://creativecommons.org[15]) - A nonprofit organization offering a range of licenses for creators to protect their work and facilitate sharing and collaboration.
2. OpenLaw (https://openlaw.io[16]) - A platform for creating, managing, and executing legal agreements using blockchain-based smart contracts.
3. LegalZoom (https://www.legalzoom.com[17]) - An online legal services platform offering resources and tools for intellectual property protection, licensing, and other legal needs.

8.6. Community and Learning Resources Here are some resources to help you learn more about NFTs, blockchain, and the music industry:

1. NFT School (https://nftschool.dev[18]) - An educational resource for learning about NFTs, covering topics such as

13. https://www.trufflesuite.com/

14. https://hardhat.org/

15. https://creativecommons.org/

16. https://openlaw.io/

17. https://www.legalzoom.com/

18. https://nftschool.dev/

token standards, smart contracts, and minting.

2. ConsenSys Academy (https://consensys.net/academy) - A comprehensive learning platform for blockchain and Ethereum, offering online courses and certifications.

3. Discord (https://discord.com[19]) - A popular platform for building and engaging with communities around NFTs, music, and the blockchain industry. Look for relevant servers and communities focused on NFTs, music, and blockchain technology to connect with like-minded individuals and stay updated on industry trends.

19. https://discord.com/

Don't miss out!

Visit the website below and you can sign up to receive emails whenever Thomas Ferriere publishes a new book. There's no charge and no obligation.

https://books2read.com/r/B-A-WZCB-YQNHC

BOOKS 2 READ

Connecting independent readers to independent writers.

Also by Thomas Ferriere

Music Business
How To Start A Record Label Online
Master Soundcloud
Spotify: The Streaming Machine
Social Media For Musicians
Launching Your NFT Record Label: A Step-by-Step Guide

Standalone
The Hunt - Carnivorous Plants
Fencing Sport: What The Heck Is Fencing Sport?
O2O - Taking Your Business Online

Watch for more at https://www.thomasferriere.com/.

About the Author

Music industry professional, former radio producer, music producer, music publisher, sound engineer, DJ, and instructor.

Granted permanent member by SACEM in 2014 for accomplishment in the music industry.

I also hold a master's certificate in the music business at the Berklee College Of Music.

During my career, I launched many music ventures and started to teach online.

I am Co-founder and CEO of a successful marketing agency in Pasadena, CA.

Read more at https://www.thomasferriere.com/.

Milton Keynes UK
Ingram Content Group UK Ltd.
UKHW020750210823
427162UK00013B/250